E S C A P I S M

words + photos

CANDICE LEE

Published by LYC Media
media@escapismbook.com

ESCAPISM: WORDS + PHOTOS

ISBN: 978-0-9979488-0-6 (Paperback)
ISBN: 978-0-9979488-1-3 (Hardcover)

First Edition: September 2016
Printed in the United States of America

This is a work of creative nonfiction. The events portrayed are only one side of
the story retold from the author's own perspective and memory. Some names and
identifying details have been changed to protect the privacy of the people involved.
Though all the people, events, places, and subjects are real, the conversations in this
book are not intended to represent dialogue verbatim. The chronological order of
some events may have been altered or arranged by the author for literary effect.
The author acknowledges that all characters mentioned, or people involved in
any form, may have different memories of the events described in this book. And
lastly, readers should keep in mind the subjective nature of human experiences.

Cover Design by Candice Lee
All Photographs: Copyright © 2016 Candice Lee
candiceleephoto.com

To Irene—

Thank you for so many years of
friendship, love, and support.

Part IV.

Part V.

The best and worst part
of losing you was
how much closer I got
to finding me

Intro.

Part I.

I was broken as was he.
Together we healed as
lovers and then friends.

Since I met him
I experienced life
in present moment.
How precious was time
so beautifully carefree.
Yesterdays were gone
tomorrows were far
every moment was now.

Now, all but memories.

Part II.

And then came another
with uncanny timing and
coincidences that strangely
crossed paths before meeting.

Since I met him
I experienced life
in complex dimensions
fractals of nature's patterns
orbits of solar rhythm
light apertures and timers.
His soul imprisoned by
both past and future--
how well I understood this.

I saw limitless expansion
but every moment an enigma,
none of which had answers.

Now, all but memories.

Part III.

And then came another
when I needed someone
who could understand me,
someone who just got me.
He embraced my distance
the way I most needed...

Part IV.

...in ways I
least expected.

Since I met him
I experienced life in
metaphysical vibrations
energies that transcend
across this universe
and this dimension.

One another's mind-reader but
tuned to the wrong channel.
How we missed the other's
true communication and so
every moment a prediction.

Now, all but memories
that replay to him and me
two very different stories.

Part V.

And then, there was me.

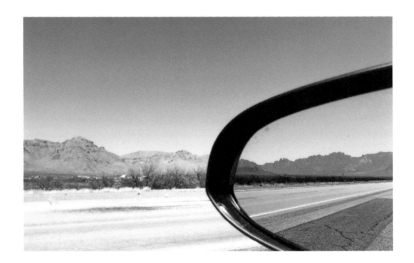

Grief makes us into fools.

We want to believe there is a reason
when there is none because we so
badly need something to hold onto
when our ground is suddenly gone.

But fools cannot move on.

Part I.

"ONIONS"

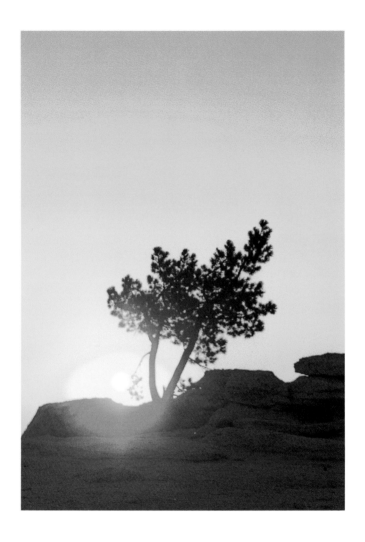

/ disposition /

I swallowed the betrayal
I made it something beautiful
I am an artist and so I created

/ no one else gets us /

I want to call him
and talk to him
about the crazy
shit that I can't
tell anyone else
and listen to
his crazy shit
that he can't
tell anyone else
as we laugh
at ourselves

because we both know
that we are so crazy
in this crazy world.

We're just two crazies
inspiring each other,
creating together,
growing the other
through our own
humility, tears,
and pain.

Our crazy works
in beautiful ways.
No one else get us
and that's okay.

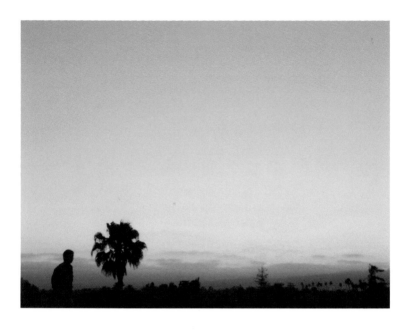

/ bravo /

you're doing fine now
and for that I'm glad

it's hard enough trying
to forget what we had

the wrinkles by your eyes
every time you laughed

you sold it and killed it
while I bought it
while I lived it

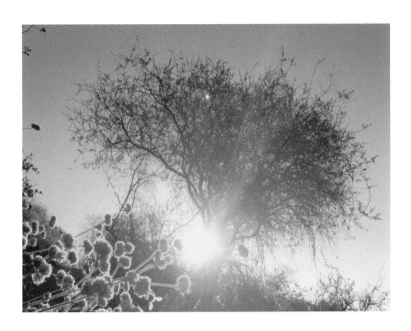

/ impermanence /

blooms wither away
nothing lasts forever so
this grief too will fade

no one stays the same
wings grow as we learn how
time shows mercy on pain

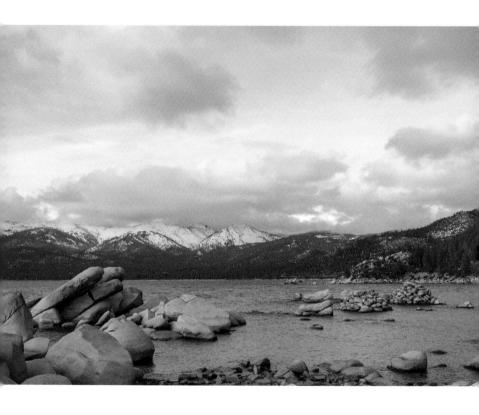

/ connections /

For once in my life I feel there is
someone else like me and that I am not
alone in my world where I would give
all for one beautiful moment.

And for once in my world someone stands
beside me and believes more than I in
the person I am in their world.

I see the colors you paint as you
embrace the life in my stills. And
forever they dance like beautiful skies
together in our world.

/ moon /

When I'm feeling
blue or like
tonight missing
you, I look at
the moon.

The stars in the
sky remind me of
times you and I
spent laughing
all night. No
worries or care
in the middle
of nowhere just
brisk mountain
air.

"I can die
happy, I feel
free," you said
to me. "This
must be life's
meaning."

Though I'm here,
you're there,
I feel closer
and less despair
seeing how we
share this same
moon above.

When you think
of me, look up
and know I sent
love.

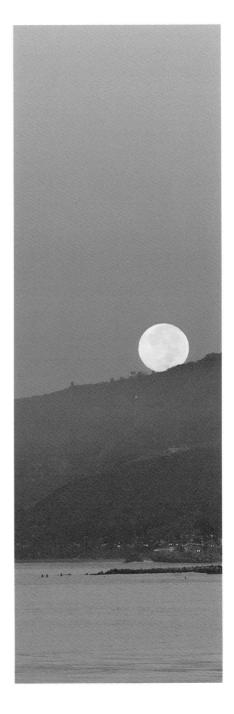

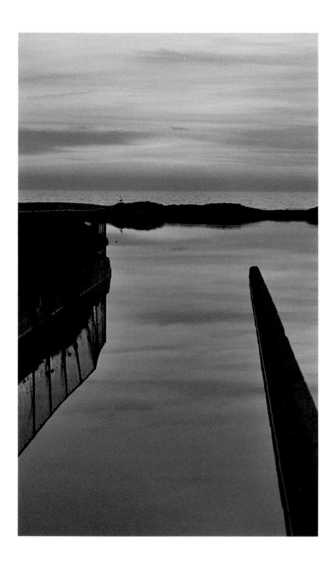

/ yesterdays /

the memories of our yesterdays
keep me from accepting the
person I see in you today

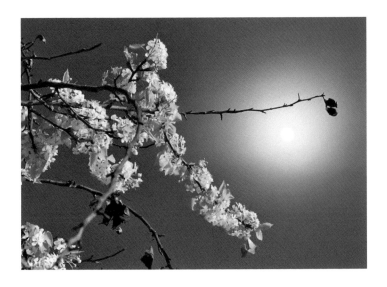

/ ignorant bliss /

Blessed with memories
that colored my days
but even more stunning
is the beautiful pain

Realizing that who I
thought you were doesn't
match what you say,
forces me to consider
how all that I've known
might've been idealizations
in my head--it terrifies me

Seeing through the shadows
that hid it's true colors
I let go of every damn
could've should've would've

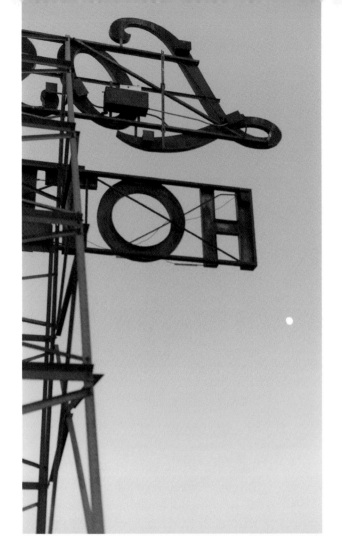

/ Dear A, /

I said just a few words,
but you already knew. You
left the rest unheard. We
both understood. This is
where we part, you and I.
Back to the start, I let
go to move on and leave it
behind. Goodbye

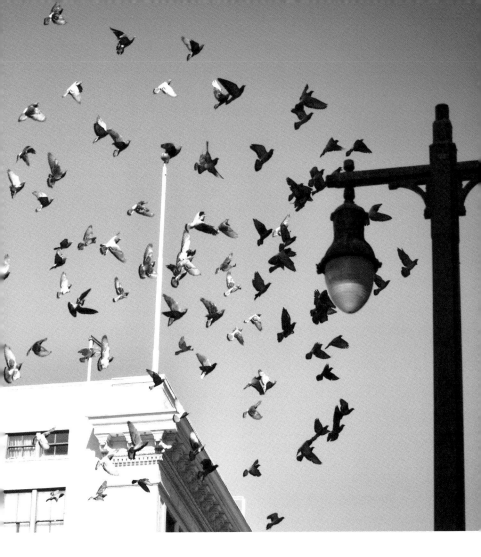

/ au revoir /

Someday I'll make this right.
Maybe by then, you will
have understood my side.
But at this moment, I cannot
as we are both burning
bridges to the ground to
mourn this chapter's end.
Au revoir, my friend...

/ onions /

Some seek the thrills of new--
insatiable hunger, new becomes old.
Others prefer the comforts of old--
quenched thirst, unwilling to grow.
I am only drawn to
ones with layers of
labyrinths, like onions.
My masochistic soul, obsessed
with mystery, I want to learn
what lies beneath, what they guard
clenching until they die trying.
I peel these onion layers
with intimate connection.
And over time, I grow to
deeply love them as
they let me in to
reveal them.

The layers are wounds,
scars leftover, that
remind us of when we
were weak--that we
are h u m a n.
These layers are
beautiful to me.
It is only after
I see theirs that
I feel they can know me.
My own layers have stories.
Even I no longer know what
they are still protecting.
Perhaps I seek these onions
with layers that run deep
because I'm searching for
me--the parts I can't see.

I want only broken ones,
ones that are running
from pain, like me.

Part II.

"DYLAN"

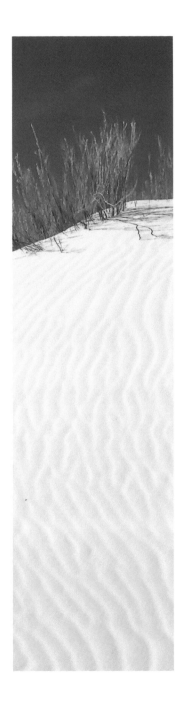

/ fractals /

You loved patterns

How my mind turned
around in circles
every time you
would talk about
how the universe
infinitely runs
repeating in
fractals

You were a nerd
but with you
life was more

My world has
since become
quite different
from before

Now all I see
around me are
infinite
patterns
repeating in
fractals

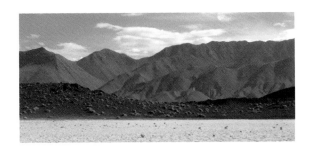

/ motion blur /

We met one summer night
He pursued with all his might
So I opened my mind and missed
my own final defensive flight

Still wounded from
the previous fight
where I had just lost
the battle of my life
trying to turn a real
connection of two minds
into something I could
once again call mine

I let down my guard
and went into the night
He captured my soul
with his perfect light
exposed with precision
meticulous sharp lines

And then suddenly...
m o t i o n b l u r
He said, "It's over,
there is no progression."

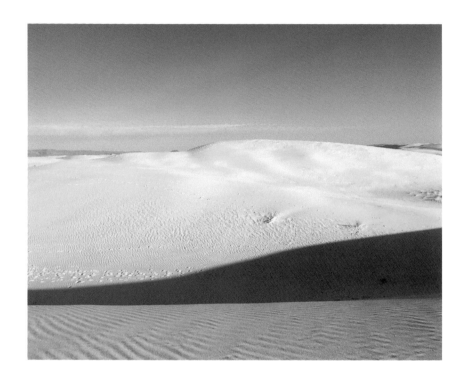

In hindsight, it was
such a bullshit illusion
spoken as if the fault
was in unison but
this dance was really
led by one person.

You grabbed my hand
without thought and
as you let go you
didn't even care to
watch me fall.

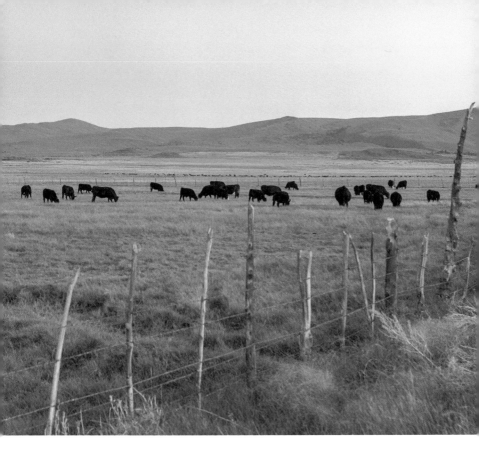

/ scraps of itineraries /

It was just a game to him.
Eight weeks gone by and still
these thoughts resound within.
Somehow I remain numb
unable to feel the sting
of the burns left behind.

I was just his passing time.
He made me a fool after
I was doing just fine.
A pawn piece in his play
I was a part of his game.

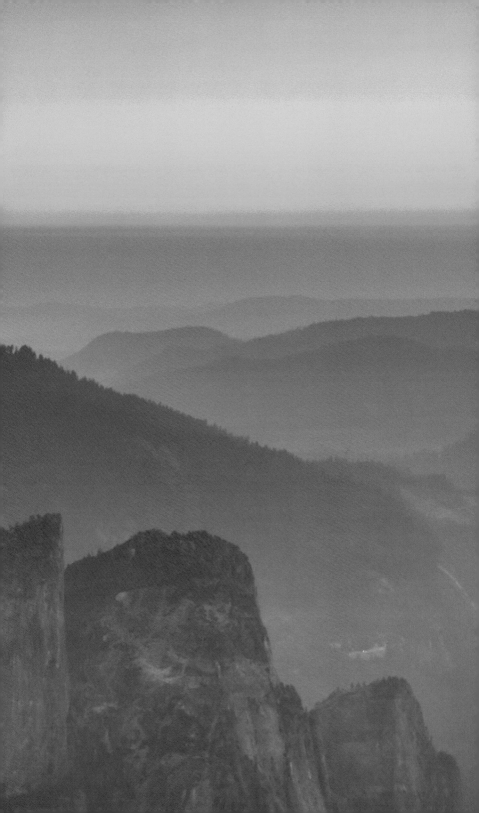

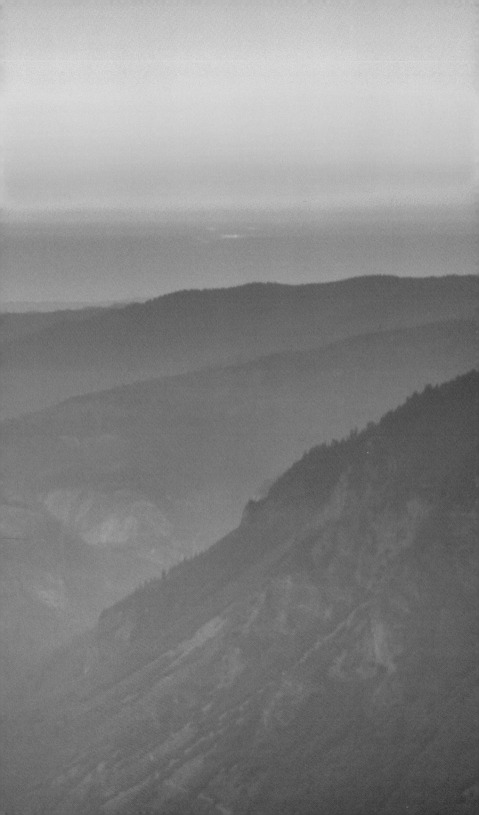

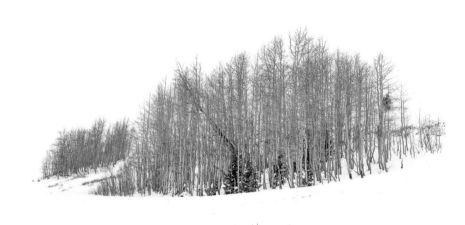

/ second chance /

His face showed regret
as he expressed his sorrow
saying he couldn't forget
about our untold tomorrow
and that he's a new man
from the one I had last met
but our story he has kept

To let him onboard this
ship he abandoned is my
crazy reckless passion

I raise this sail knowing
I'll drown if we fail
just because it is him

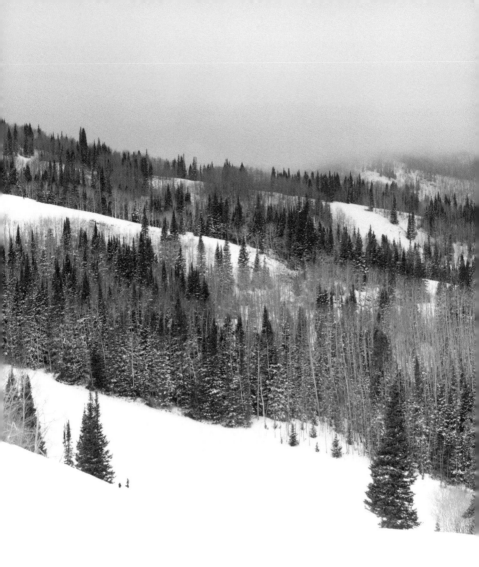

/ fight or flight /

Let my strengths
guide me now before I
break my self-made vow
and ask you how
I may try, try, try,
beyond what I
would myself allow.

/ disconnect /

I don't know where to begin
I wrote a letter to him
that I wasn't able to send
and for whatever reason
things are coming to an end

I just feel it
his resistance
the distance
our disconnect

the end

/ tin man /

I didn't know that
people like you existed--
merciless with tact.

You are a liar
your ego deludes with fire
your mind feigns power

when you are nothing but
a feedback loop replaying
the same damn story

forsaking progress
as you solemnly confess
that I'm meaningless.

With much disregard
for my compassionate heart
you broke me apart.

And as for me I'm left
stunned and betrayed again
as cold blood flows within.

So used and abused.
Not once but twice confused
how I trusted you.

A shell made of tin
protects your agonizing
pain trapped deep within.

/ piano man /

I still remember
how eagerly you played
my favorite melodies to
impress me, even though
you already had me

/ last words /

You were searching for
reasons to walk out the door,
"Your drive is so poor

you'll never be more,"
you said, like salt on a sore.
"This time I am sure."

Words that dropped my floor
you crippled my strength and core.
We've been here before.

You don't know how to
care for another, but you,
and my love you used.

Never again think,
for even just a second,
that I'll forgive you.

This time I'm sure too.
You never once planned to
choose me, like I chose you.

/ illusion /

This doesn't feel right.
You want the best for me
yet you refuse to try.

I was there for you, I
cared for your pain as mine.
So now I need you but you
are nowhere to be found as
I am left on the ground--
near, far, not a sound.

How a trusted friend
gives up on trying to mend,
so easily as you did...
kills me from within.

My beautifully fabricated
illusion of a man--a shell
trapped inside his own hell

/ rain /

Raindrops fall and I
think of you. I wonder if
you're listening too.

/ mind stalker /

You are on my mind
like a sickness your absence
will not leave my sight
You walked out of my life
You should be out of my mind

/ cruel path /

I gave you my trust
Why would you
believe your lies
over me or us?
How do you say those
words to someone
you care for?

The pain you impose on
those you kept close is
the cruel path you chose
to guard your heart first

/ rambling haikus of why /

grieving our story
i sit here writing questions
that plague me, to D-

why wasn't it me?
didn't i let you fly free?
what didn't i see?

why couldn't you try?
wasn't it you who asked for
round two and more time?

it was fight or flight
and still i opened my heart
once more, didn't i?

laughing and happy
was all i wished us to be
i saw you and me

was it that easy?
how'd you stop so suddenly?
all our memories--

they're either all lies
or you put on a disguise
while you watched me cry

pushing me aside,
doesn't it hurt you inside?
please answer me, why?

facing our ending
isn't as easy for me

-thinking of you, C

/ rewind /

I'd like to forget
and return my life to a
time before we met

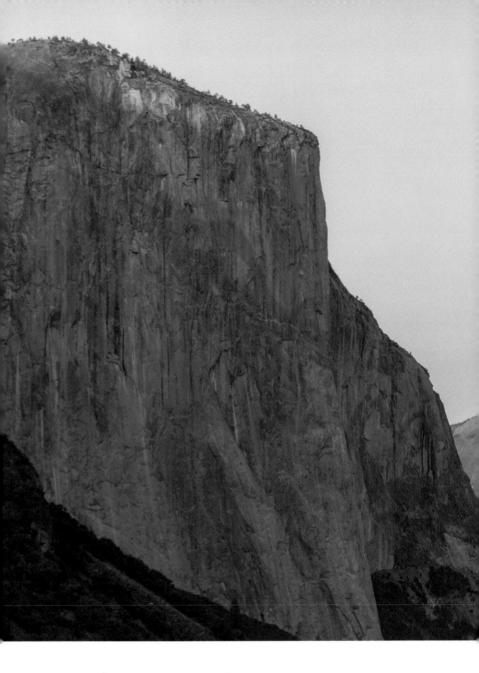

/ dark skies /

My days are all lies
I think of the girl I knew
before these dark skies

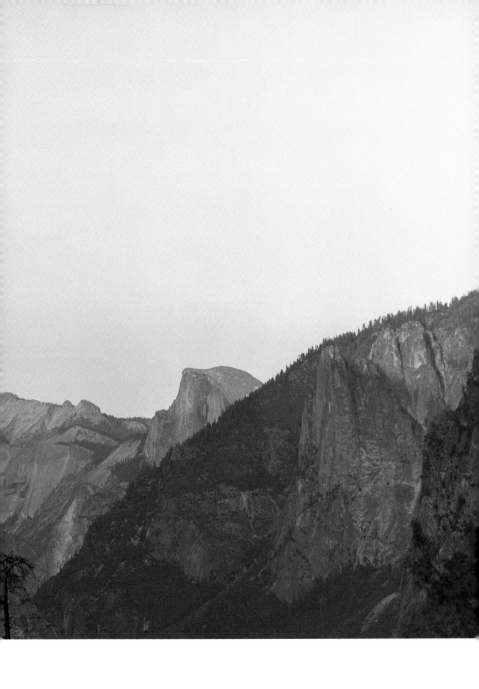

I bet you don't know
it's taking everything
in me to let you go

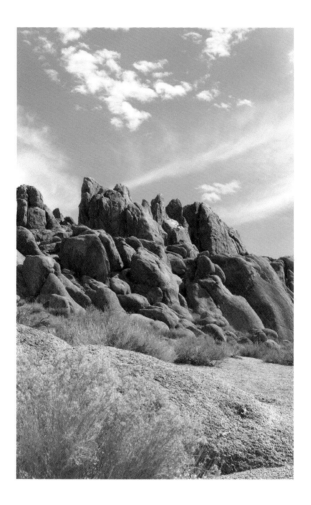

/ 395 to LP /

Lone Pine, we meet again.
Such a quaint and rural town
brings a city girl like me
back to keep revisiting and
then to leave again weary
since this one in particular
holds bittersweet memories.

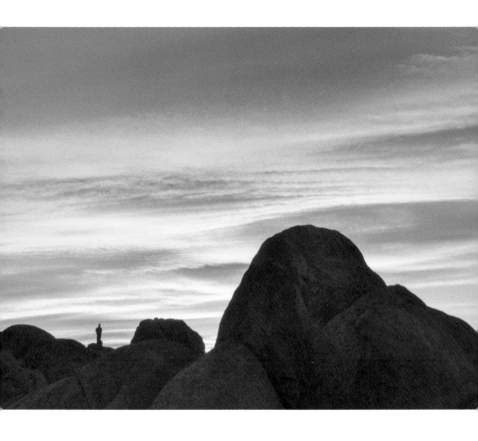

/ word vomits /

The time spent apart
has my mind thinking over
how different we are

Often I wonder what
spell I'm under as I still
miss you as you are

Your stubborn silence
stings--I feel undeserving
It overwhelms me

/ nostalgia /

Even when I retreat
and change everything
around me, our story
continues to follow me.
It finds a way to subtly
recall buried depths of
graves in my memory--

like how this morning
a hairband suddenly
brought me to my knees.

Funny how nostalgia can be
like real beings, fighting
to stay alive, insisting
it's not yet their time.

/ photographs /

Now the lens feels so heavy
as it invokes my memory of
a strong passion that
he and I share for the
art of landscape imagery.

To those I've yet to explore
and ones I've yet to capture
in your wild untouched nature,
please stay beautiful and pure
for a little while longer

as I rebuild myself to
show up with a new view,
with everything to prove,
to nothing else, but you.
I will come back for you.

/ untitled /

Time is passing so slowly
Few weeks seem an eternity
I wonder how you're doing
and hate myself for caring

...I'm no longer angry
just in case you
feel like calling

/ third date /

We kissed in the bar
and I don't think at all of
why you never called.

He's not you, sure, but
I remember you never
held my hand before.

While he spoke he'd pause
to ask me what I thought
as any good man should--
something you'd seldom do.

He likes that I don't
give a fuck and that I won't
do just 'cause I'm told.

He stopped me mid-word
didn't care where we were
and pulled me in closer.

We kissed in the bar and
now he strums his guitar
singing me his song.

He's not you at all.
For a while, I forgot how
far from me you are--

the distant memories of
your hands and how they
danced on those piano keys.

He plays a new tune while
I miss hearing your blues
but for tonight, he'll do.

Just one more night to
keep my mind off of you and
gently pull me through.

We kissed in the bar
but I knew in my heart
he won't be, like you are.

Part III.

"RESIDUALS"

/ linger /

Linger in my dreams so
I can let you go gently
when I'm done healing.

/ new lover /

My old lover is fading
quickly from my new life.

No longer do I wish his face
to disappear from my memory.
I see more clearly that my
longing for him, and for us,
was rooted from my pride.
Thoughts of our past bring
me waves of inward shivers.

I sleep with a new lover who
I'm letting him into my life.

Last night he held me and
said my body was overheating.
So we conversed on topics
going off on tangents until
he mentioned that my temp had
cooled down, and that he'd been
monitoring it with his touch.

Lying in his arms, I feel
how easy it should be
when it's just right.

I understand now, the
old lover was never
meant to be mine.

/ distance /

"Where did you come from?"
he often asks me, teasing,
as if I'm a rare species and
I am getting drawn in more
to see where he is going.

When he reaches for my hand
something feels different as
I want to close the distance
that I'm so used to giving.

/ peculiar feels /

So strange are these
kind of moments when
my heart knows something
that my head does not yet.

Sensations wiser than
thoughts of reason
leave me with feelings
that need no confirmation.
Peculiar you are, intuition.

/ this guy /

He reveals his past
pain and isn't afraid
to show that he's
simply a man who's
traveled a long road.

I feel safe next to
him even though I
don't know if I'll
see him again or
where this will go. I
just like his spirit
that flies free as a
bird. With him I feel
wanted more than I've
felt before.

And though he's a
wanderer, something
tells me I can trust
that he'll return if
I keep my heart open.
He's not one to be
tied to just one place
or time but deep down
inside neither am I.

And so he has my
attention now, this
guy.

/ stop sign /

Whenever I'm with you my mind wanders away as you remind me that the light ahead is red. I get overwhelmed with laughter as we get lost in a bubble, away from all the world's trouble.

When you drive away, your mind must still be with me as I watched you leave and you missed the woman crossing. I tried not to laugh since she got so angry, but I couldn't help it after you started yelling back so coolly.

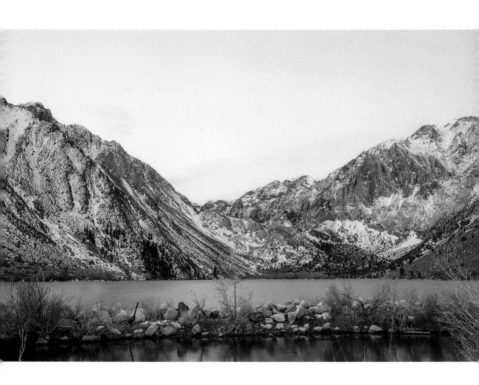

/ cold war /

all the dreams I have
require my greatest focus
so don't hold me back

to keep you at bay
as we continue this way--
my cold war within

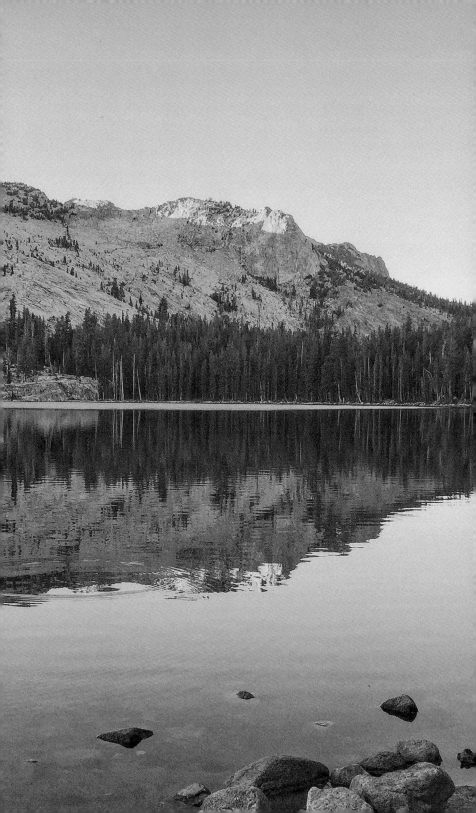

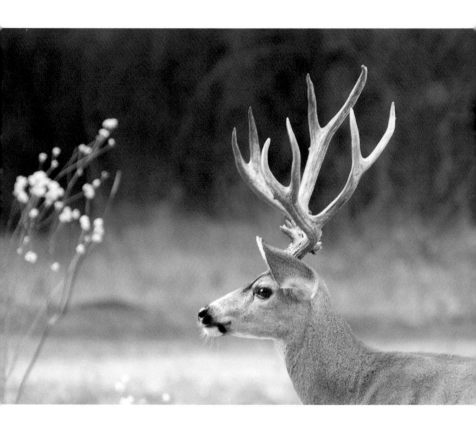

/ masochist /

I'm no good right now.
There's nothing I can give
I left it all with him.
If this is meant to be
we'll see it through
and with time it will
just happen with ease.

But at this moment
 I will push,
 I will pull
again and again, on
 the repeat.

I will drive you crazy since I
have plunged so far down inside
my own history where darkness
vetoes this newfound bliss--

 summer noons at the beach with
 our feet in hot sand, laughing
 all day, then green nights back at
 my place, watching videos of old
 live rock bands again and again,
 on the repeat, with you.

He hurt me. And I am angry, in
a dark place, but I am trying
to move forward--without him.

You are wonderful, best I've had yet.
So now I like you too. And if we dig
each other, that's all good--and all
that should matter--but it's not. I'm no
good right now, since I still want him.

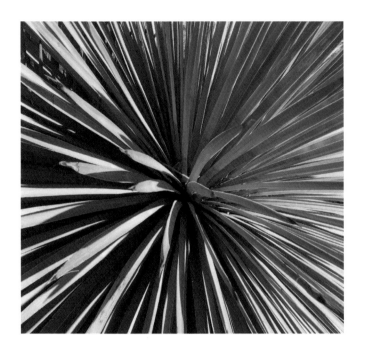

/ final boarding /

It's easier to fly
away from him as my fears
prepare for departure.
Before the beginning,
this flight was boarding
to go anywhere, but here.

I'm not ready to fight
I'm too fragile to stay
so set me free before
one of us pays.

I'm leaving.
After today.

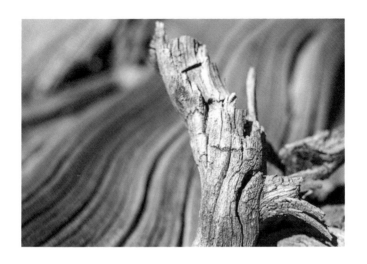

/ rebound romance /

It's been sublime
getting to know
your free mind
and sweet soul.

But my baggage
is heavy to hold
and this burden
is mine alone.
My heart's intents
are in survival mode
and my conscience
cannot be fooled.
With what remains
in my control I'm
letting you go.

I hope you find your
hidden mines of gold.

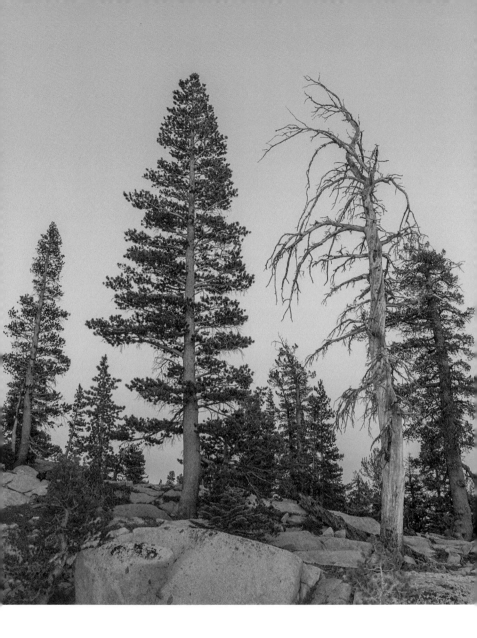

/ interlude /

Why haven't you called?
From what we were
to nothing at all
feels impossible...

/ residuals /

I thought I'd be okay now
after you found your exit out
but since my rebound fling
is now nearing its ending
my mind is quickly racing
to find another you for me.

I lie that I don't give a shit
until your memories creep back
to painfully haunt me.

The hole you shot through me
is once again gaping.

/ lost /

Running from pains of you
and now I don't know which
romance I am grieving.

How lost I've become
distracting myself from
your absence upon me.

I see now that I've been
my own enemy, too weak
to fade your memory.

/ familiar /

What should I believe
after you seemed happy
to hear from me again?

But then once more
I'm left hanging
onto empty words.

So misleading, as it
was back then, like I
was never your friend.
I guess you're not ready
to make amends yet.

Selfish and thoughtless--
how your terms treat me.

Strangely it's calming
as I am reminded of
what is so familiar
between you and me.

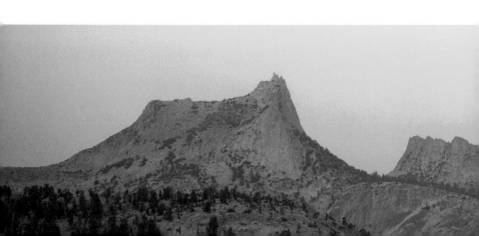

/ end interlude /

It's getting harder to erase
the moments we shared.
They say time heals all
but it feels as though it
is working against me.

The silence tells me
you've moved on and
want to be happy
without me.

It pains me deeply to
leave that as our
ending. I gave
all of me.

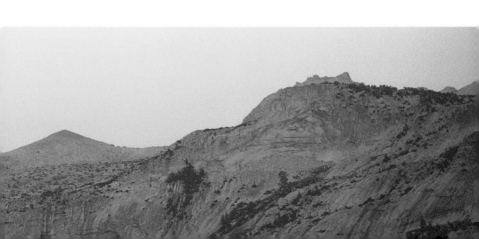

Some things need
to be left ugly
without creating
beauty from it.

Some things
should just be
left a mess and
never looked
back on again.

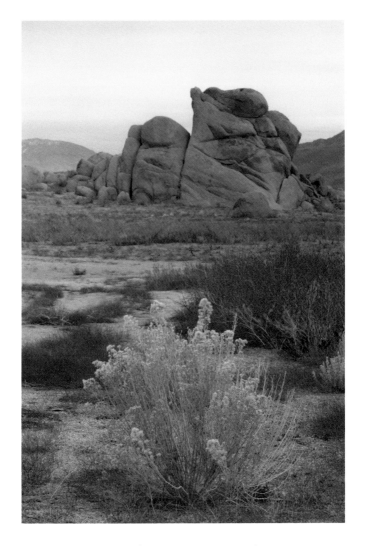

/ heartless /

I loved too much
I hurt too much
I dream too much
and I feel enough
for the both of us

/ Displaced Blame /

It took me so long to see how
I hurt you and that I also have
blame to carry in this bitter
ending of what we shared.

Now this guilt is killing me
inside because I know that it
is far too late to make right.
I could have trusted my gut.
I could have held you closer.

Instead, my fears took over,
and all I gave you was passive
pressure because I was insecure
and weak--too afraid to show you
the respect that you deserved.

In these realizations,
I have no one else to scold
but my own selfish thinking
and for this, I feel so sorry.

It was convenient to blame you,
so much easier to hate you, I
chose to see the worst in you.
And like this, I grieved you.

I'll take it with me
and learn as I move
forward with what
I have left today.

Our memories are safe,
irreplaceable, and dear.
Now, I finally believe
what we had was real.

Part IV.

"BRANDON"

It's not everyone's forte
to be able to openly convey
a willingness to extend
and grow with another being
while exploring our
deepest feelings.

The antithetical irony
behind all we strive to achieve
while maintaining our autonomy--
a juxtaposed dichotomy,
this double-edged sword of
being, all while, in love.

/ I got you /

How does he do that?
That thing where he can
sense what I've been feeling
and as if he prepared himself
he takes it all in as I share
all my fears along with my
thoughts that have reached
a block, paused, tangled
in its own complexity...
and then suddenly, not.

His calm soothes me with
such ease. It lets me know,
he's got me and we'll be okay.

I don't know how he does it
and it doesn't matter anyway.
I'm just glad we both stayed.
Words we used to say present
themselves now in different ways.

Comfortable ... with you
as if we've met before--
another time, another place.
Transcending space through
this moment--familiar and new.
I'm so comfortable with you.

Let's keep doing
this, whatever it is

I don't care about
tomorrow or what
will come of this

I'm letting go slowly
of his bitter memories
and they feel better
further behind me

Let's be happy and
stay in the now
I don't care how

Just like this
enjoying the bliss

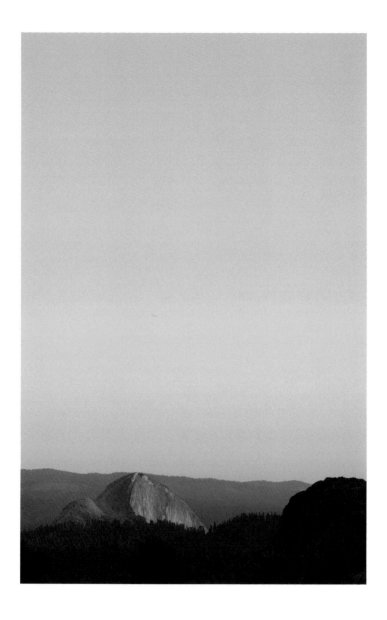

Waking up next to you
is the only proof I need
that this is not a dream

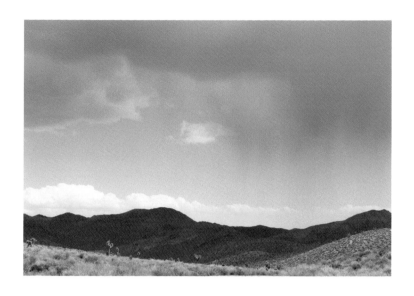

/ be patient /

This connection feels real
so please be patient with me
and with time, slowly
I'll let you into my world
which now seems more full
than it ever did before.

It's hard to believe that
this is now my reality as
I'm not used to letting
someone else be a reason
for how happy I'm feeling.

I hope I don't take
too long to show you.
Please be patient with me
and with time, slowly.

/ clumsy /

we are getting closer
while in murky limbo grey
my fears pull me further but
now it's hard to walk away

this is all new for me
as I feel so unsteady
and even more clumsy than
the words on this page

/ pressure /

The momentum is
building between
you and I. The
window is here,
slowly escaping.
Let me in now as
p r e s s u r e
is building.

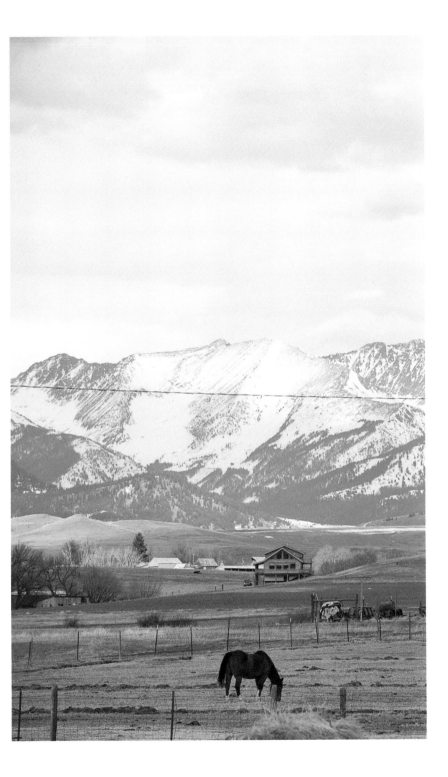

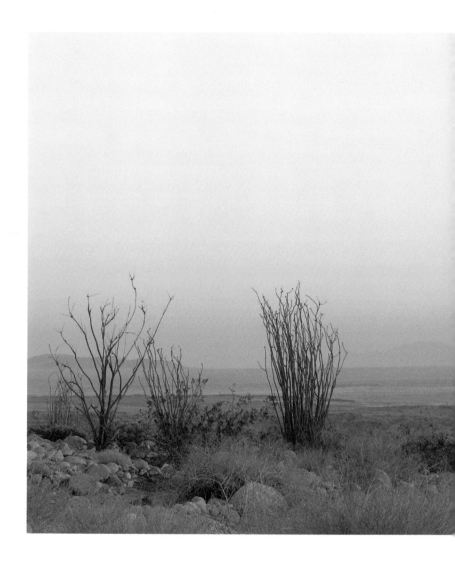

Paths cross through time

We rewrite what could be
but feelings are fleeting
 so we keep on moving

/ left field /

There are these moments when I'm hit from
out of left field with feelings--opaque,
so unclear.

I thought I was done reading that last
chapter--I know I'm done reading that
story. I keep trying to give meaning with
theories of why things ended between me
and Dylan. It was some time ago, but then
come these random moments when it feels
so near.

Days after we parted ways, it started to
rain and my first thought was of him--
wondering if he was listening, or maybe
timelapsing, the drops...falling. I still
knew him.

It took many sunsets, but his thoughts
are no longer with me whenever I lose my
breath in fragments of nature's beauty.

I thought I was done healing, progressing,
no longer running.

Today--

Months after we parted ways, it started to
rain. I watched the clouds glow from pink
to purple, in massive forms, too beautiful
to watch it through a frame as they were
quickly passing and darkness was nearing.

I thought about Brandon and wondered if
he was also watching until that text came
in, out of left field.

It was Dylan. Saying something about the
sky and how it looks amazing, that he heard
up north it was snowing, that he loves when
the seasons are changing...I replied with
a photo, at the same time his photo to me

 --the same cloud, now purple,
 in identical framing--

transcending the distance that had grown
between us, sharing this view we're both
now watching. And I never saw it coming,
whatever this is I am feeling.

/ floodgates /

You. You show up unannounced. Like a tsunami, you drag and pull all the emotions I've so meticulously, so thoughtfully, put to rest. And c l e a r l y , I don't know how to deal--whenever it comes to you.

You. Your coy "hello" actually let open a floodgate to all the feelings I didn't know how to say goodbye to before. It was too hard for me to handle it all at once. But I've found a perfect balance, a trickling release, so I can take it in slowly, as much as I can for now, at least.

This floodgate of mine, was the only way to grieve you because of the overload I'm hit with when I let it all out. It's tricky, a bit twisted. Maybe masochistic too, since this overflow of emotions, kept safely, is secured by this floodgate that only **you** have the key to. And you don't understand how this was the only way I could go on to be okay again. All the questions unanswered that night, I've been answering during my time after the break. Most of these get thrown back behind this floodgate too. I'll get to them later when I'm ready.

This was doomed. I am screwed by my own floodgate system because of course, over time I start feeling better when I meet another man who at most times is able to keep you completely off of my mind.
 But, I am mind-fucked.

And I did it to myself. You see, after a while, I said I was fine and believed that I was no longer affected by what had happened between you and I. But, f u c k.

I forgot about that fucking floodgate.

This is all fucked and I say this now because the keyholder to that gate just showed up with a friendly greeting and some talks that were too familiar to the ones we used to share when we were together. And this gate has opened, and I am drowning, and overwhelmed by the overhanging presence that is, you. You need to make yourself clear. Are you secretly hoping--third time's a charm? I've moved on from our story, in case you're wondering. Are you thinking--we can be friends? How will that work when I still have so many fucking questions about what happened?

So many emotions and intangible storms in my inner world that you just left me to deal with all alone...No, we can't be friends like this. Then what? I've seen you do this coming-back-for-you thing before. What are your intentions? Just make it simple, floodgate-master. Fuck.

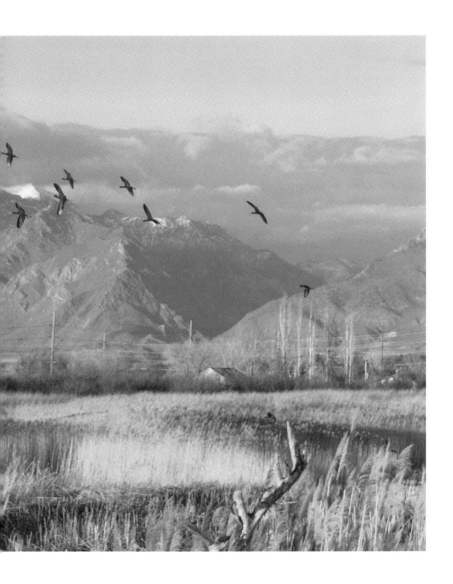

The anvil I've been expecting has
most surely crashed through this
roof, made of my own fantasies,
that made it so easy for me to
escape my reality

/ no trace /

I never noticed until now.
His room looks the same as it did six months
ago, when I first saw it--music, books,
journals laying by the bed, landscapes,
and bits of images to keep him inspired,
to motivate him. Prints that I've given
him--keepsakes of us, bits of me, bits of
him, bits of life since he met me--remain
stacked in the envelope on his nightstand.
Objectively, an insignificant detail that
shouldn't be dissected. But subjectively,
I cannot ignore this as I compare my room
with his.

And I never noticed until now.
The numerous frames I've changed,
replacing its contents with photographs
of my life, that now has him. I took
them down, only recently, because I got
shaky and it no longer seemed easy. At
times, it felt like we were pretending.
Maybe my intuition found deeper meaning,
starting from the beginning--how he
resists integrating me with his world.
Introductions of convenience, to get him
by, while I've been building him into mine.

I'm noticing now, it's not just his room.
There's no trace of me in his life.
There's no room for me in his world.

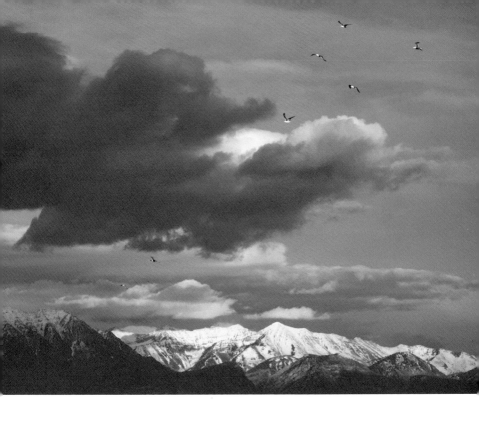

You make it too damn easy
for me to walk away and
leave it all behind as if
we were nothing at all

Fight for me you fool
Prove it to me the way
I would for you
Be a man

Be my fool
stay

/ crazy /

I took down our pictures
We look good together but
they make me feel bitter--

longing for something no longer
with us, something that I've
been really missing lately.

The way he used to want me.
Holding me close, pulling
me in without fear, he just
wanted me near saying,
"You drive me crazy."

That guy from the bar who
kissed me in mid-convo as
we got lost in our world.

He knows what he wants and
he engrossed my thoughts
like no one ever did before.
He drove me crazy...

Walking down the street,
we carried on laughing and
he pulled me in close saying,
"People must think we're crazy."
We created memories.

I don't know who you are--
not that guy from the bar.
I miss him, crazy.

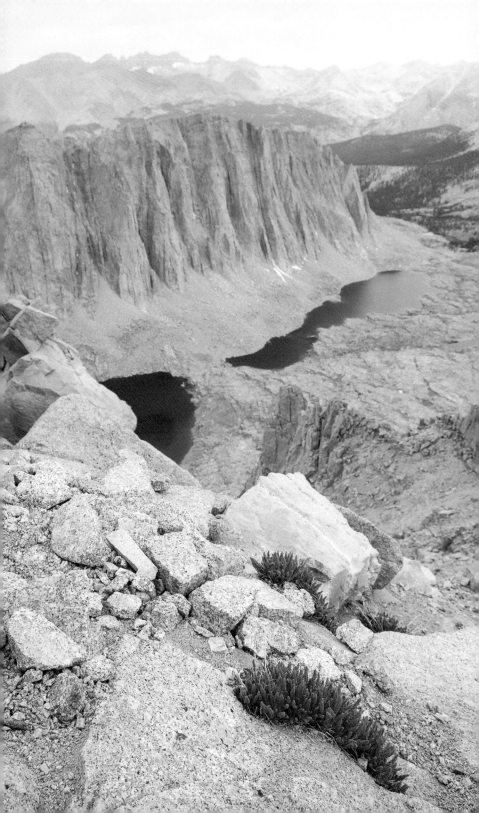

/ sweet summer fling /

And so my attention now diverts,
to something else in my life,
something that returns the same
passion I put in it each time.

Just let me be with the good memories
and we'll leave it at this. This way,
we're left with only a sweet linger
when we think of each other later.

I don't have the energy
to break myself down
in order to start over.

/ rose-colored fade /

...He does the motions but
I don't feel anything
real coming my way.

Last month it was
all about his play.
Next month it'll be some
other lack of, or simply
him continuing to flake.
I'm always last on his list
someone he just wants
for convenience's sake.
And so...he's losing me.

I'm starting to stray,
looking away, expecting all
of this and whatever we are
to just, dissipate.

Checking out now, good day.
And the music starts to fade...

/ moot /

Even if you say
we're worth it and you'll stay
my doubts will still remain.
You were in the grey
so quick to hesitate and
now it's just too late.

Your words become moot.
Despite how much I want to
I won't believe you.
Etched in the surface
again and again so now
they're scars that won't fade.

To this fork we've come.
Both paths lead to poor outcomes.

Goodbye, it was fun

/ zugzwang /

The idea of you,
this image that
I created, holds
its fascination
inside my head.

The truth of
your being, now
threatens these
idealizations that

light my passion
leaving nothing for
me to believe in.

Before you speak
to kill it

I leave it.

/ happy birthday /

In my perfect world, today I'd be making
pancakes saying, "Good morning, you."

Silently, I'm here wishing you a beautiful
day, hoping you'll feel it coming your way.

Happy birthday, you.

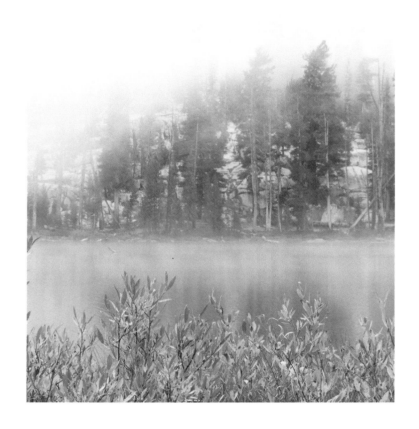

/ universal /

raindrops falling bring
melancholy that takes the
edge off my grieving

somehow comforting
this ubiquitous weather
relates with its gloom

We met for the first time since his
birthday--the day we entered this,

limbo whatever break.

He seems to have fallen deeper somewhere,
maybe into his own despair. He wasn't there.
He said he's been staying busy, he hadn't
really thought about us, how that was the
point of this break, and why should he?

Like this, the night carried on, much
like a first date gone wrong. We argued
on the walk back to my car. I needed
a read, just give me anything as I've
been driving myself crazy. I asked him
what he needs and what he wants from me.

 --Apathetically he replied,
 "I don't know."

It was **he** who wanted to stay friends as
of our last meeting. So here I am, now
seeking him there as he'd wanted but now
insisting it wasn't. And I, frustrated.

I walked away without reply as
I couldn't even begin the why's.

We've both grown so irate and angry.
We never yelled like this. Who were we?
With all of our good that always
outweighed the bad, this was the moment
that could tip the scale--and then even
time wouldn't avail. So I chose beauty and
left that scale heavy with all our happy.

/ where are you /

When was the last time you were with me?
Thoughts race through my head as I replay
all our memories from beginning to end.
What, where, and when?

The man I saw yesterday was just a shell
leftover from when I had you. I miss
you, and how you used to say, "where did
you come from" and "you drive me crazy".

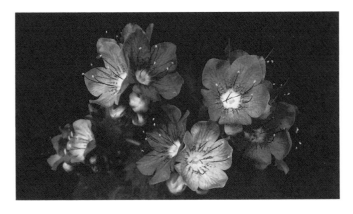

Where are you? I miss you today.

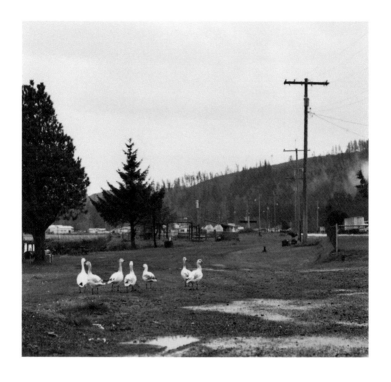

/ our own language /

He and I, we have this thing--
We talk to each other without speaking
We feel what the other is thinking
We just get it.

I'm not ready to let go of feeling so
understood. I have more I want to share.
There's still so many layers within my
inner world that I want him to know.

/ strangers /

I started
looking for
a trace
that was
familiar
but there
was no sign
of him in
the man
s l e e p i n g
beside me--
who wouldn't
come near me
and retreated
when I went
to him.

He wasn't
comfortable,
like we were
strangers.

And I knew
my lover
had left me
w i t h o u t
l e a v i n g
a signal
that he
would be
returning.

I got you.

/ not the same /

I wrote a song last night
this time music before words
because I feel so much grief but


Strumming away with no direction
hoping something will click and
into it I can unload this pain.

I lost my best friend.
Now things will be different.
I know change is good but
I just want him back again...

It reminds me of that one time
we picked out bracelets from a
cart along the market street.

> He pointed and said, "I'd
> like that one, please."

The woman tried to give him one,
closer and easier to grab, that
looked the same but he said,

> "No, I like **that** one."

Me too.

/ nobody's home /

It was so sudden
As if his soul
just flew away
when no one
was watching
No "goodbye" or
"see you again"
He's g o n e

You're not him
It's not the same
I cannot stay
I'll come back
when I'm ready
but not today

/ lies /

He asked for some space. He said that he
needed a little time--that it might just
be a case of his winter blues. "I don't
want to lose you," he explained, "If so,
I will come back on my own, but right now
I want to be alone."

> He's not coming back.
> He lied and we both knew.

I said that I would wait for him, but
that right now I have to leave in order
to grieve and heal so that I can come
back as a friend at least. "I'm not going
anywhere," I assured him. "I'll be there
for you. Our connection will be anew."

> I can't be his friend.
> I lied and we both knew.

We lied unintentionally
to give the other hope and to
ease ourselves of the imminent
pain we would soon face alone.

We lied to give the other a
final gift they could hold onto,
a faith to pull them through,
because we only had each other.

> We lied for strength.
> Because walking away
> is hard enough to do.

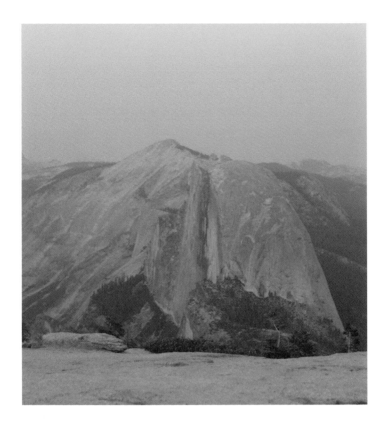

/ remember me /

I know I shouldn't be angry since
you weren't yourself when you left
me hanging.............. but, I am.
I'm so angry for being abandoned.
And I don't know to whom it is directed.
Is this denial? This might take a while...

...get there faster. Remember me.

/ passive /

This trait of yours, is one I hate.

Don't let me down gently to spare me my
feelings for the sake of preserving your
nice-guy identity. You're not being kind at
all by disrespecting me with lies that keep
me hoping, waiting, twiddling my thumbs so
patiently until one day I understand the
truth--what you're so afraid to tell me.
Just say it. I can take it. **END IT.**

You must not know me and how long I can
live with hope, how long I can hang on to
your words, how loyally I can respect your
"time & space"--as long as you ask me to.
And no, this is not stupid of me. I don't
care what people think. I wait because I
stupidly trust you, because you asked me
to, and because I have faith in you. I am
a dreamer. Please don't mistake what makes
me, me, as an easy route for your escape.
This is the essence of my being and all
that I am. Don't make me a fool and leave
me alone to blame only myself at the end.
Don't make me hate the one thing I truly
love about me. All this is not worth the
image you are trying to save. I will see the
true you, no matter what you say. **MEAN IT.**

You will ruin me this way. Don't be passive
when it comes to my feelings, my dreams.
Don't be this coward. Be a man, stand up
strong. Kill my hope before you walk away
to leave. Silence this suffering. **SAY IT.**

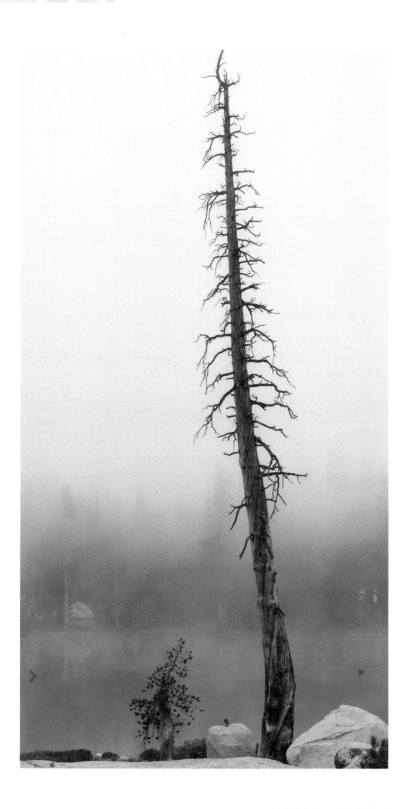

/ breakup via silence /

It's raining tonight
I hear raindrops--f
 a
 l
 l
 ing
as they did on that day
when the one before him
declared our separate ways

This occasion is different
yet again in this room alone
with my feelings

I'm realizing how much I really
 loved
him. How he is different
and how much I will miss him
He is my best friend yet
it's all coming to an end

/ final parting words- /

How could you be such a coward?
How could you leave me in such disbelief
to a point where my shock is veiled by
a merciless hope--the worst lingering
denial that drives a person mad? How
could you not think about me? How did you
just run away without giving a farewell
closing, a chance to start healing, to
start accepting, to finish this together
at least? Now as the shock is fading, I
am seeing so clearly--what you took from
us and the dignity it deserved to grieve.
You never cared about me.

I feel so grateful to the ones before
you, all who you called "awful men"--they
were much better than you, at the end.
They cared about me. They left me with
my sanity. They knew it was necessary to
give me a chance for serenity. How could
you do this after all the time we shared
together? You were my person.

I had weeks of waking up in the middle of
the night screaming, hallucinating that
an intruder was standing by my bed. I
didn't see it then--my subconscious trying
to warn me--as my psyche was in shock,
unable to accept the truth of what was
happening, of what you were doing, of how
you chose to simply start...f a d i n g.

/ -unspoken. /

How deeply you played my grief and
into a fool it made me. How I was
still waiting for your voice to spea̲k

before the world said it to me.

Why you would choose this way,

 instead of coming to me first,

 I'll never know.

The clarity goes in and out

 but right now,

I am lucid--seeing just how badly you
wronged me and our story. How we were the
least of your concern; how over it and
past us, you had long been without saying,
drawing strength until you could stand
on your own again.

```
...for  my  own sake
my rampage roared
as  a last resort
to  open  my eyes
to  wake  up  and
smell  the  roses...
```

```
                  and I still can't
                  believe that this
                  is    the    w a y
everything we shared is unfolding.
But it is.
```

Part V.

"Every act of creation, is first
of all, an act of destruction."

-Pablo Picasso

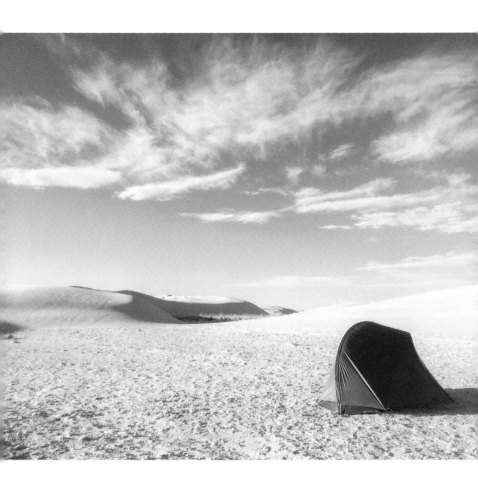

/ alone with me /

Doubts that question my sanity
because how I feel doesn't make
sense with what you're feeling

And I don't know how to deal
with this pain in healthy ways

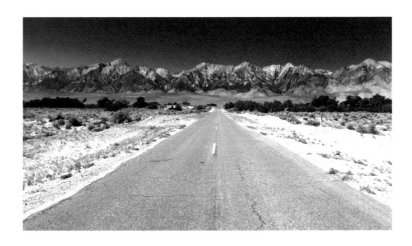

I'm angry with you--
pushing me away, forcing
me to face myself

I hate that I lost
myself in us before you
found yourself there too

No, I won't forgive--
you left everything a mess
like I am nothing

I don't want to grieve
all our memories right now
It's all I have left

of my closest friend
of the most special romance
I've experienced

I'm angry that I
believed I was more to you...
believed we were real

It has been one month
since I ran away, unable
to move on from the loss,
afraid to face the pain.

/ mercy /

I don't know what else to do to ease
this...how do I describe this...instability
within me. Waves crashing against rocks,
back and forth with no end, and there is
just me--a piece of kelp at the mercy of a
force much greater than anything I've seen.
The ocean always frightened me.

This inner world that is
 my **hope**, my **dreams**, my **feelings**,
 my **soul**, my **anger**, my **compassion**,
 my **faith**, my **beliefs**, my **memories**,
 my **pain**, my **inner peace**,
 --this is **my** territory.

How dare you exert so much power,
so much force, so much control, over
what belongs to me? Who are you to put
all that is mine under your mercy?

When I invited you in, it seems I trusted
you with my life. So pathetic--I'm now humbly
kneeling to the grace of time and praying
to a god I don't believe in to please
return this inner world that is mine. Only
what belongs to me, nothing more, nothing
less. Desperately I swear, I'll be more
careful moving forward... just make it stop
crashing... I am drowning... I am dying...
This is over my head, much stronger than
I believed, a feat even too great for me.
For the first time in my life, I am
truly under a mercy that is not mine.

/ escape me /

The plane touched ground
and I am now back in my
hometown, which I've been
recently running away from

Streets are too familiar
People burden with questions
I'm leaving again tomorrow
I can't stay here when our

memories easily find their
way back to my mind, all
the time, even when I say
that everything is fine

I'm not escaping this world
I am simply exploring it to
let your thoughts escape me
And I desperately need

some time away from the
goodbyes we never said
some distance from the
looping replay of yesterdays

/ cold caterpillar /

Earlier this morning, the frigid icy temperature of this mountain's February air woke me from my sleep. Rude awakening. It was cold. Inside this tent, I am somewhere, amongst unfamiliar surroundings. So cold. And in my suffering, I reminisced the last time my teeth chattered uncontrollably as so.

In this same tent. Brandon, next to me. We were along the river in the mountains, where night temperatures dropped below freezing. With my sleeping bag wrapped tightly, like a human caterpillar, I inched toward him as the heat from his body was emanating. And it woke him. But, I couldn't help it--I was shivering and his warmth, I needed.

This morning it was just me, caterpillar and all, inching in towards my own self. There I was, in fetal position, thinking again and again,

> --I don't need him
> I will do this on my own
> This is survival mode
> I can take this cold--

repeatedly, over and over, until I fell back asleep.

 As if I was brainwashing myself, reprogramming my own thinking.

/ holding on /

Somethimes we hold on
even long after its gone
because we don't know how
to make sense of what's done

Sometimes we keep feelings
we know we must get rid of
because we can't make them
disappear--poof, into thin air

Sometimes the memories linger
whether or not they are shared
because we can't pretend as if
nothing was ever there--we were

Sometimes we lie to the world and
put on the show they expect from us
--that we're strong, we've moved on,
we're numb, over it and done--but we
still feel it, just to keep going

Sometimes my anger is stronger
Sometimes my compassion takes over
Sometimes my grief sees you tomorrow
Sometimes my pride cares no longer
Most times my heart does not follow
Sixty days since I saw your face
Somehow it still feels like yesterday

/ white flag /

I'm tired, but I don't want to sleep. It's cold inside. I feel hollow. Empty. Words don't flow as easily in this state. Time to call it a day. I gave it all I had, everything in me. I need my own saving. So I raise this white flag--I am defeated. Nobody wins this game...not like they imagined. We come back different once we reach a place so dark, like the one I am now in.

Who should I mourn when everything and nothing is dead? Where is my hope, when I need it the most? The tragedy is right here, within me. How do we survive once we bury a feeling that consumes us entirely? How do we say goodbye without losing ourselves completely?

The storms that raged violently have passed, but this stillness inside is unnerving. How does someone like me, just be--without feeling? What inspiration can I now draw out of myself, to create? There's nothing left, not even a ghosting emotion.

/ surrender /

just go
i believe you
go be happy
i finally see
it's not with me
just go
before i beg
before i realize
i am alone
again
just go

/ muse out of you /

Remember our story
the one you left so easily
without speaking a word to me

Watch me turn this pain
into a torch of passion
Watch me erase your place
with tiny bits and pieces
Watch me eradicate it all
every last memory of you
and watch me--closely

Watch everything I do in the
aftermath of what you threw
When I am done you will
still think of me fondly
but by then your purpose
will have been a petty tool
to me with which I created
my masterpiece

Watch me turn you
into meaningless paint
Stronger than you because
I'll rebuild something new
Better than you because
I didn't have to hurt you

Watch me make this
beautiful again

Watch how I make
a muse out of you

/ i tried - acoustic /

 C G
It wasn't my best side
 Am G
but couldn't you have tried
 C G Am
before leaving us out to dry
 C G Am
Didn't even bother to lie
 F Fm C
And I never asked you why

 Am F
Do or die, you died
 Am F
So far out of my life
 Am F
So deep into my mind
 Am F G
Do or die, I tried

 Am F
Your silence always implied
 Am F
what your heart never felt
 Am F
Fuck your reasons why
 Am F G
the excuses you never said

 F Fm
My soul search ran dry
 C G
Over and over I played
 Am G
our memories in my head
 C G Am
Over and over I bled
 C G Am
Over and over there's
 F Fm C
nothing's left to save

```
      Am              F
       Now it's my
     Am              F
     turn to call and I
       Am              F
     want your ghost and your
         Am           F
       wandering eyes gone
             G
       Go on and go, get

       Am                F
     Outta my heart outta my soul
       Am              F
     far, so far, out of my sight
       Am              F
     Out of hands, go on and fold
         Am      F      G
       the way I know you will

                 Dm
             Truth is, I
             E
       finally see the light
       Am                  G
     You were never really mine
           Dm
       so this is my goodbye
           E
       You wanted this fight
         Am                G
       You wanted this right?

         Am          F
       So far out of my life
       So deep into my mind
       Never really mine and I
         Am      F      G
       tried, tried, I tried
             C
           It's time
         I'm coming back
           to life
```

/ NB via 395 /

Lone Pine--memories both good and bad. But with time, the bitter ones are fading. Skipped Alabama. I can do without it. I messaged my Whitney crew that I'm thinking of them. And just like that, I passed right through this small town, like it never meant a thing to me.

I'm searching for a new beginning and feeling so blessed for the people in my life, currently.

/ everywhere /

What is right, who is wrong...
Who cares? None of it matters.
Pride means nothing at all
from the bottom of your fall.
Nothing can fill up this void--
all these disappearances from
your life, the dreams that
follow no matter how many
miles you traveled to go
anywhere but here.

/ 6 weeks 6 states 6 parks /

And it only took one moment to remind
me how much I still care. I can't
keep running. I can't keep pretending
that you're not there. Everywhere.
You are still e v e r y w h e r e.

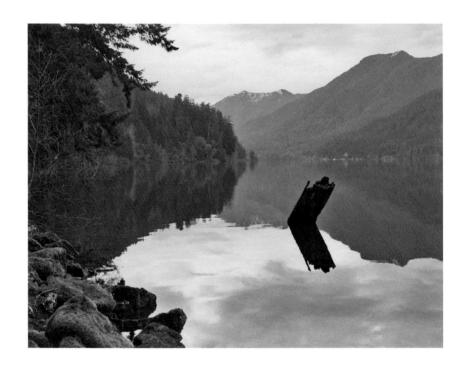

/ ashes /

ask me to stay
give me a reason
not to leave
miss me in ways
i'd feel or say it
before the breeze
blows it away
come try again
say you want me
don't let me leave
not like this
not in this way

/ special part of me /

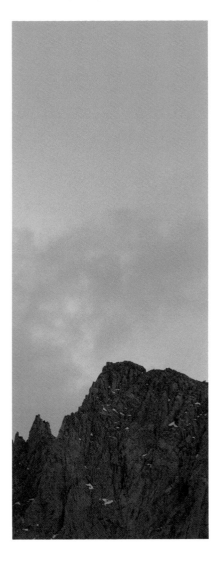

Pain deepens the wounds in my soul just before a n o t h e r memory of us turns numb as if I was nothing in your world.

Yet m i n e turns slowly, moving on through my own self-destruction. A train wreck just waiting to happen.

Because such a special part of me is dying from within and all I can do is feel it. And let it.

I envy those who can fragment their stories and be done with its existence. I envy people like him who can love without losing pieces of themselves--just me.

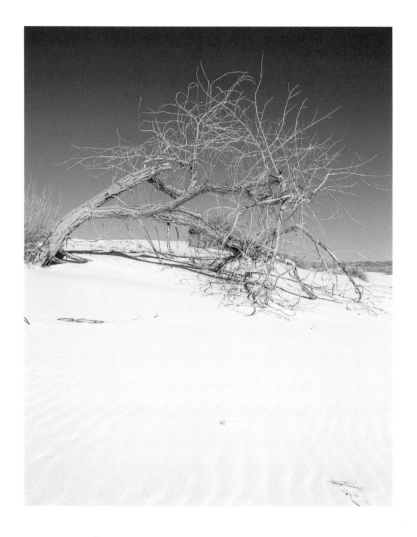

So suddenly he
turned stranger
while I held on
to whatever was
left between us and
now it all lingers
in no-man's land
this limbo

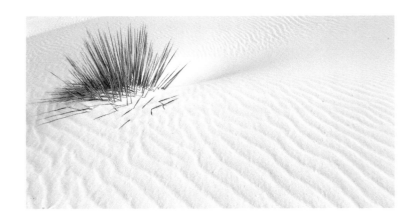

/ limbo /

Where do our memories go?
If you no longer care
I can't keep them in here
they only bring me tears.

My mind stays open yet
nothing holds them safe.
Nothing you left for me
to embrace when you're
not in my life anymore.

You made it crystal clear
your feelings aren't there
far away from what we shared.
Yet I am still waiting, here.

But if I let them all go
what was all our love for?
Where does it all go?

/ pressed flower /

We woke up in your bed and because
you were you, I slept in while you
went out to get us coffee. This was
our typical morning. You returned and
gave me an iced coffee with a flower
on the lid, one you picked for me.

It wasn't much, nothing grandiose like
in the movies, but it said so much
more to me. You were never good with
words when it came to your feelings.
This was the first time you told me
I was special to you, sans words--
this flower, your voice. I felt the
kind of joy that is so happy that it
brings a slight sense of melancholy as
the moment is passing. Nothing lasts
forever. Time turns and these moments
will soon be memories. This flower,
so poignant, it moved me. I wanted to
f r e e z e it, all of it, and what
it meant to me.

I knew this day would one day come
when we would no longer be. So this
pressed flower, now dead, reminds me
of the beautiful ways you spoke to me.
You were never good with words when it
came to your feelings. But it's okay--
this flower told me.

I knew it back then, and I know it now. And though this pressed flower is all that is left, I can still remember your feelings. It's more than a memory--those can change over time. This pressed flower is proof of how you once felt about me. Proof of our story, our language, our friendship, our romance, our happiness, our bond, all that is now gone.

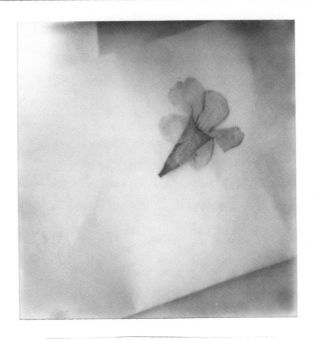

/ pressed flower /

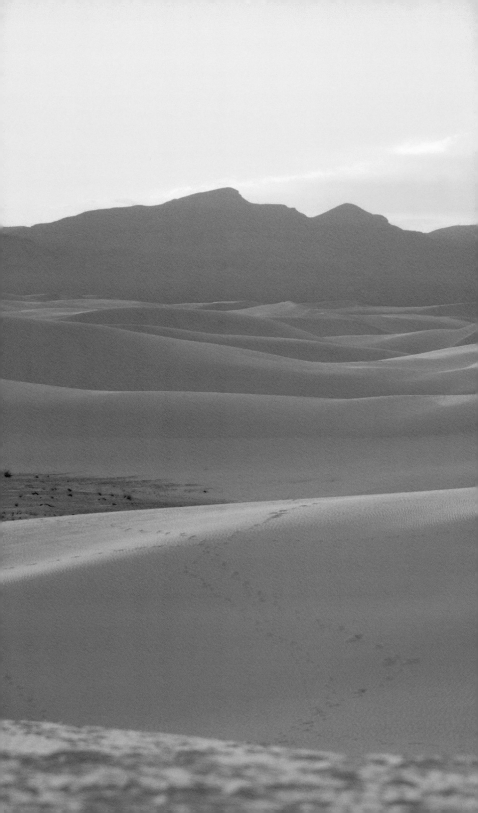

/ cubist face /

It's getting harder to remember you or to imagine the embrace I still desperately miss. Your face that was once engrained so perfectly deep within my memory is now a Picasso painting. I am Jekyll & Hyde when I realize you are fading. One side of me repaints your face whole again, while the other thinks you look better this way.

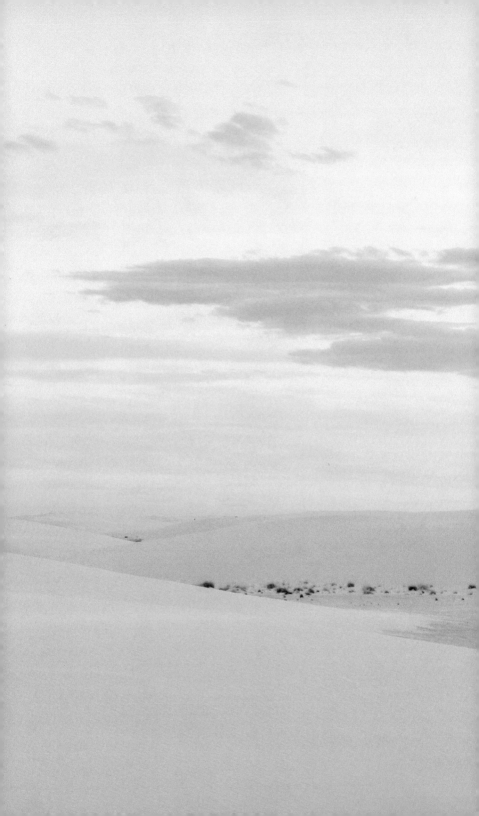

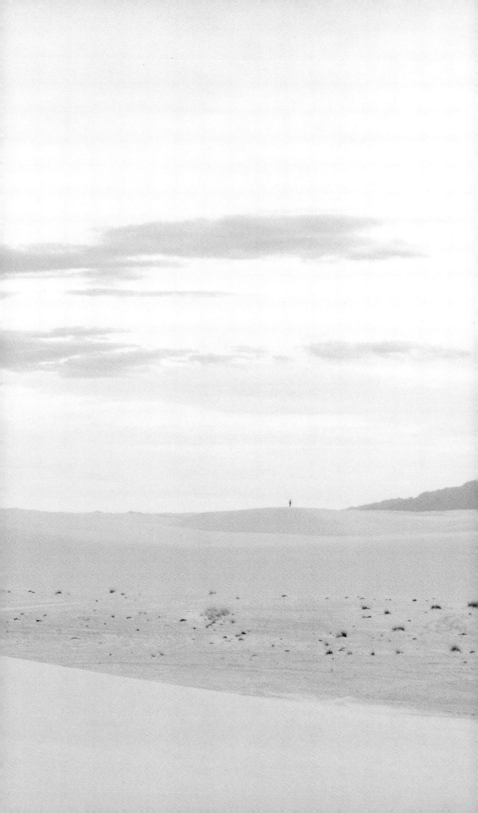

/ seventeen years /

You were my friend
from beginning to end
You and I
 We were so
different, but I liked it

The world may never see
another duo, like us two

The time and distance I created
selfish, I was, during my
lone cycles of heartache--but,
I can't say that I regret it

 If that's all it took
 for you to forget our
 friendship, then you
 never knew the space or
 depth in my heart that
 I've always kept for you

/ reese's pieces /

At a cusp between peace
and the insanity of fury
I now stand here at
the end of our story
I reminisce the memories
and smile alone, but fondly

Let all that we were
continue to live on
gentle as we both move on

It's better to leave at this
in the height of what is--

this grace of forgiveness

/ perspective /

How this bird flies
graceful free alone
The hunt for prey
determines its way
not so different
from human psyche

Nature in you and me

Perspective divides
which story plays
Commonality unites
where understanding
fades the initial pain

Peace of mind begins with "I"

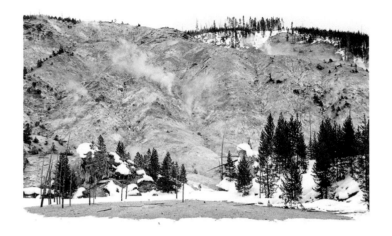

/ nuances /

no one else knows
when i wake up the
first thing i look for
is food anything whatever.
with eyes still half closed
i reached across her space
and grabbed her peanuts--
i ate them all.
no courtesy no expectation
to ask for permission.
i cut bullshit. she knows
i do what i want and
manners are for show.

we were once that close--
rawness behind closed doors
intimacy without fear
of showing the real me.
maybe no one will again know
nuances of me in this form.
no one else knows but her.

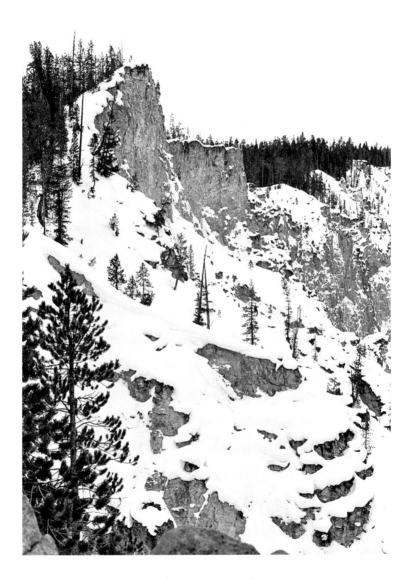

/ frozen /

And it stays beautiful permanently
because it has ended, and gone.

/ maps /

There is nothing I would change
even if I had a chance to redo.
What came from us--it's beautiful.
It is rare. And, we are rare...

We are a dying breed **because** we shed
these tears. They leave footprints
as we go, mapping paths to and from
all the ones we cried them for...

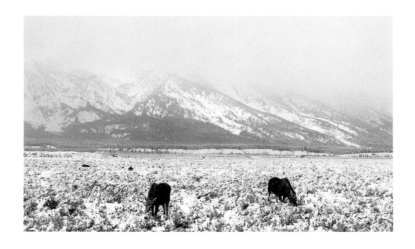

Only later, will we see what we
did it all for and the legacy we
still carry on to show. That it
never dies where we let them go...

All these dead ends--seeds, we planted.
Long after we go, they continue to grow
with their beholder. It stays with them.
And they will remember us forever...

They will never forget us, because
we loved them.

 And we love them.

We are a dying breed...
Fearless in love, we become stronger
with each one. This world fears us.

All these places and traces--trails of us
that live on. Maps that lead back to us...

So don't forget them.
Let them grow

 Go...

 You loved.
 You did enough.

/ bird dance /

birds fly together
in a flock like a dance
but one or two always stray
and the flock carries on
dancing as the song is still
playing--the show must go on

/ Irene /

I'm home now, here and ready to
press play. But this is not where
I left us to wait. Everything has
changed.

The price I paid I acknowledge
today, on your wedding day, with
no words to say. Tomorrow was too
late and nothing stays the same.

Leaving it behind, myself I would
find. To show something for it,
I finally wrote this. This is
my story of while I was away. At
least now you know--my demons I
faced, the places I went, and my
escape to be alone.

Of our most recent years--
I should've been there, I could've
done better. But stubborn pride
speaks silence.

The past cannot be changed and I
am always late. Your tears were
valid because you know me. And
you remember us.

Of what is left, I write--
Congratulations, I am so proud
of you and who you have become.

Words, I could not say--
I'm sorry and thank you. I got
this far because of you.

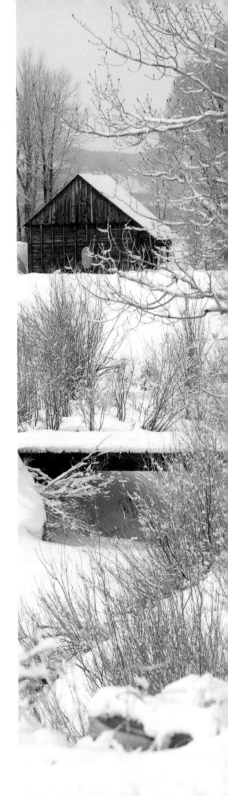

/ winter in Montana /

I found what I needed.
And, **everything** that
happened had it's purpose
it's own time and place.

Answers, that I went off
to search for, came back
around in full circle.
Because, I guess, that's

the nature of patterns.

Escapism--avoidance
of fears, made real
only as we let them,
beginning and ending

with journeys. Now
home back to me, back
to you, and back to who
we are meant to become.

For You-now-reading,

You are close.
And we both know
you're not alone
because, you
inspired me.

Thank you.

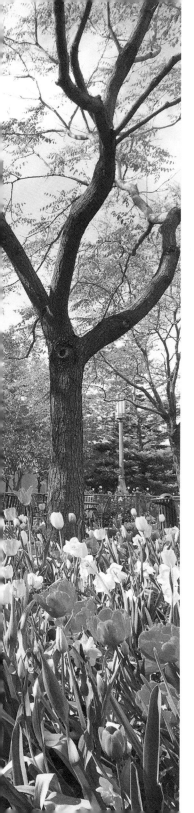

...patterns
infinitely
repeating...

I feel the signs all
around me as if it's time
to run again. But, I've
grown. I'm different.
And this feels better.
I want to run with you.

You make me laugh.
 I make you insane.
You make me feel weird.
I hate it and I like it.
Let's get out of here
the world will still
be crazy as we left it.

Off to a different place
another time and journey.
I'm feeling familiar
vibrations all around
me until I notice it's
been a while since
I've smiled like this.

And did I mention already
you make me feel weird?

 I'm happy

...in fractals...

And the story continues
 as it always will...
 because THE END's
 are bullshit
 and this
 is not
 it

CPSIA information can be obtained
at www.ICGtesting.com
Printed in the USA
LVIC06n0422290916
506306LV00002B/2